May all those I mention here regard this book as theirs as well as mine. It could never have been achieved without their support, since no one is alone in this world and nothing can be accomplished without the help of others. I would like to give special thanks to Amberley Publishing for all their support, and for choosing me for this project.

Thank you to: Peter White Mclen, Paul Carson Clark, Helen Chadfield, Kerry Browning, Rodrigo Dos Santos, Lisa Jane Slaven, Camron Cube, Murray McRae, Laura O'Neill, Laura Nagelschmidt, Irene Molina, Alwyne Sienkiewicz, Michael Clarke, Morvern Cunningham, Stuart Hepburn, Christopher Rutterford, Danual Dior, Kevin Baines, Marc Diamond, Ross Hepburn, Joel Perez, Georgios Ntavelas, Aung Zin Tun, James Crombie, David Jimenez, Alistair Steward, Elyse Black, Edgar Guerreiro, Molnar Marton, Peter Miller, Jonathan Rumford, Daiva Malina, Katie Rougvie, Muzzy Hamilton, Nicola Robertson, Louis Thomas, Graham Fennell, Michael Wdowiak, Natalie Candlish, Tartan Heather, David Lazaro, Zeena Mindikowski, Biff Paris, Victoria Sanchez, Frances Fowle, David Gordon, Alex Slater, Reyes Mayolin, Benjamin Frances, Shannon Ferry, Larissa Susin, Elea Karlsson, Fernando Diaz, Benjamin Suarez, Alberto Sanz, Susane Meaney, Estefania Garzon, Kaddeer Aslam, Melissa Knox.

Last and not least, I beg forgiveness of all those who have been with me over the course of this year and whose names I have failed to mention.

In deep gratitude,

Manel Quiros

First published 2017

Amberley Publishing
The Hill, Stroud
Gloucestershire, GL5 4EP

www.amberley-books.com

Copyright © Manel Quiros, 2017

The right of Manel Quiros to be identified as the Author of this work has been asserted in accordance with the Copyrights, Designs and Patents Act 1988.

British Library Cataloguing in Publication Data.
A catalogue record for this book is available from the British Library.

ISBN 978 1 4456 5977 0 (print)
ISBN 978 1 4456 5978 7 (ebook)

Typesetting and Origination by Amberley Publishing.
Printed in Great Britain.

ABOUT THE PHOTOGRAPHER

Manel Quiros is a freelance photographer born in Barcelona, Spain, in 1984. He has been established in Edinburgh since 2010. He graduated in Photography, Image Processing and Communication at the University of Valencia, Spain, and Visual Communication, Media in New Technologies and Photojournalism in Edinburgh and Glasgow, United Kingdom. An active member of the CC NGO, he has collaborated with the Naya Nagar NGO, the Spanish Red Cross, the Burkinabe Red Cross, UNHCR (the UN Refugee Agency) and the World Food Programme (WFP). Over the years his passion for photography has taken him to various European countries as well as Bolivia, Burkina Faso, Egypt, India, Bangladesh, Thailand and Cambodia.

In 2014 he was selected as one of the PHE14 Discoveries at the PHotoEspaña festival, Madrid, Spain. He was a finalist for the International Contemporary Art Award Combat Prize 2014 in Livorno, Italy. In 2015 he was awarded an honourable mention from IPOTY (International Photographer of the Year) in the category of Photojournalism/Story. He was also featured in the book Contemporaries: Thirty Photographers of Today, a welcome and innovative publication that discovers and gives credit to a new generation of distinguished photographers. He was awarded bronze and silver at the Tokyo International Foto Awards in 2016, as well as winning the 'Lens on Social Justice' contest held by the Open Hands Initiative in collaboration with VII Photo Agency. In the same year, he was the Juror's Winner in the Documentary Photograph exhibition held by the SE Centre for Photography, Greenville, South Carolina, United States. He also won the international portrait photography award 'Shoot the Face'.

PETER WHITE MCLEN
HOMELESS

It's just one of those days, you know? Some days you wake up and you are alright, the next day you are not. Ups and downs. I live in this cemetery. This bench is my bed. People are scared of coming to the cemetery. It is the best place to sleep, no one is going to come and annoy you, and dead people are not going to bother you, so I can have a good night's sleep. I am not scared. It is a safe place. Where are we anyway? Oh, right, now I know where we are.

PAUL CARSON CLARK
OWNER OF CARSON GALLERY

I enjoy the cultural side of Edinburgh. We have everything from a big city in a small city. I have been selling maps for thirty years now. There are not too many jobs like this one. I like the idea of handling material that is three, four, and even five years old. They come from all over the world. Look at this map from Edinburgh; it is from 1582.

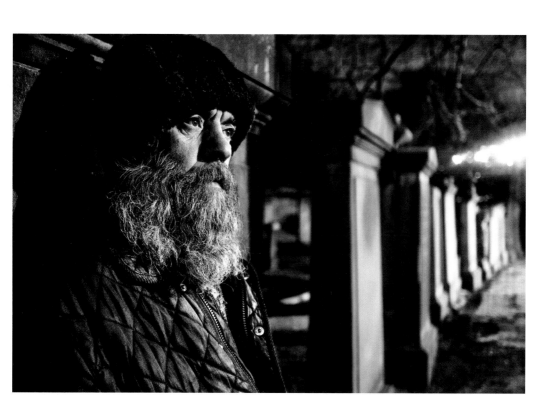

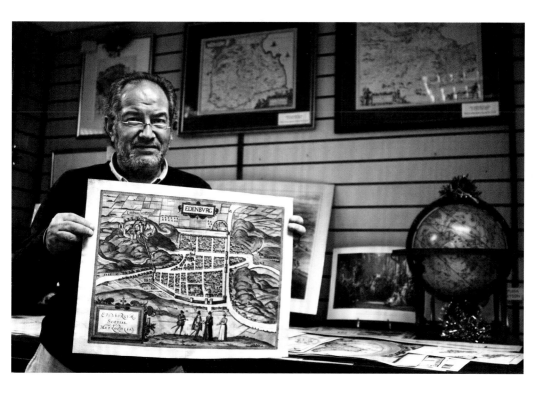

HELEN CHADFIELD
DIRECTOR OF JUST FALCONRY BORDERS

Just Falconry Borders is a mobile educational facility that involves education, demonstrations, and history of traditional medieval and current falconry. That's why I am here in Edinburgh, to pass our knowledge to everyone that comes by. We love our birds.

LISA JANE SLAVEN
TAXI DRIVER

As I leave my flat in the heart of Edinburgh, this beautiful city I am lucky to call my home, I jump into my licensed black cab to start my day. It is a strange choice of career for a woman some may think, but not so, it fills my heart with pride. I firmly believe that happiness is not a destination but a journey. I hope I bring a little bit of happiness to everyone who journeys with me.

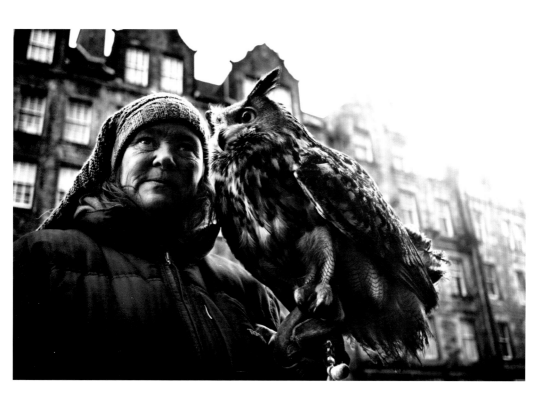

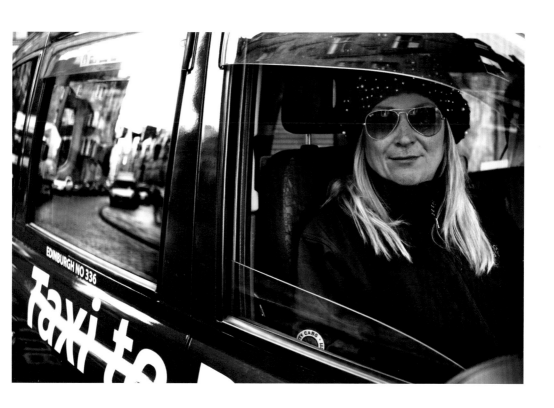

KERRY BROWNING
MANAGER OF EDINBURGH BACKPACKERS

I came to Edinburgh three and a half years ago as part of my travels. I loved it. I found a family and a home away from home, so I decided to stay.

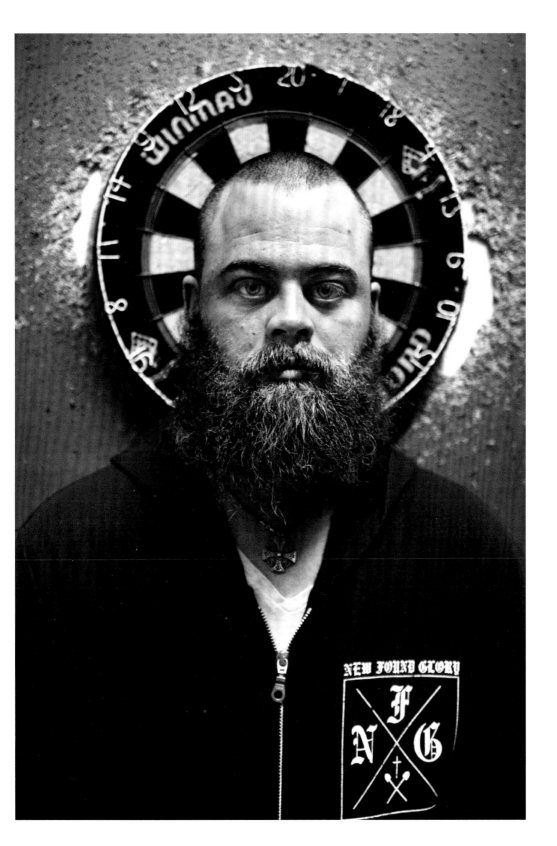

RODRIGO DOS SANTOS
GENERAL MANAGER OF SOUTHERN CROSS CAFE

I am a vibrant and thriving person, just like Edinburgh. That's why I love to live here. What I really love about Edinburgh is that every August the city hosts the biggest annual international arts festival in the world. It is incredible how many options you can choose from.

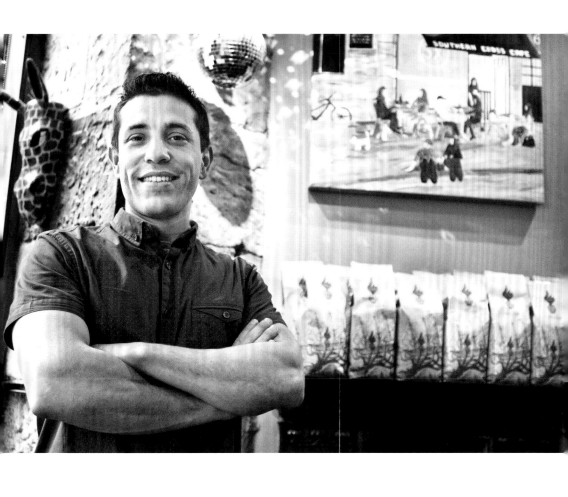

CAMRON CUBE
DIRECTOR OF CUBE EXT. LTD

From a young age I was exposed to LA gang life, then was blessed with an opportunity in the music industry. Who'd have thought Edinburgh would end up being my home! The hospitality industry feels right and is where I belong. I have been able to adjust to almost anything and everything in life. I believe that everything happens for a reason and not all that glitters is gold, so you must work for your own prosperity.

MURRAY MACRAE
OWNER OF STAG BARBER

I was twenty-six and I felt that I had to fulfil my dream; I had to open my own barbershop. Now I have a small, quaint, men's hair salon in the Old Town area of Edinburgh and it is almost two years old now. I love it. Every day is different and I meet so many amazing characters. We have it all. Edinburgh is an amazing capital city that has the feeling of a small town. I feel very happy and extremely proud to call it home.

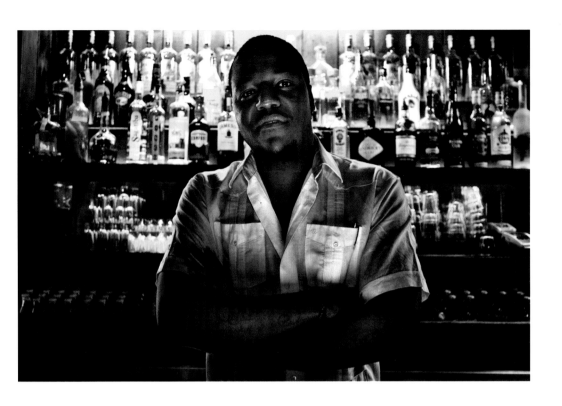

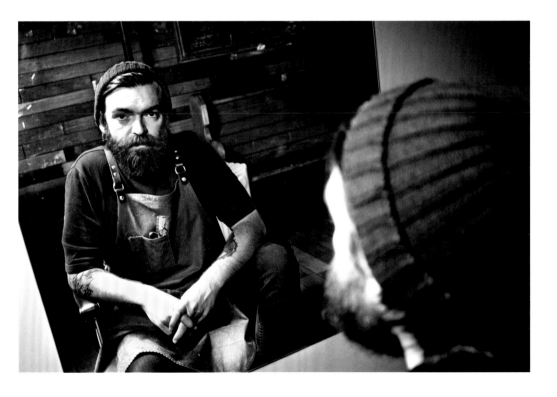

LAURA O'NEILL
OWNER OF MAISON DE MOGGY

I've always been passionate about animals. A visit to Japan inspired me to bring the concept of a cat café to my home town of Edinburgh. After months of spending every spare hour and every spare penny acquiring the fluffy jigsaw pieces that became the Maison de Moggy family, the cat was out the bag and I opened Scotland's first cat café in January 2015.

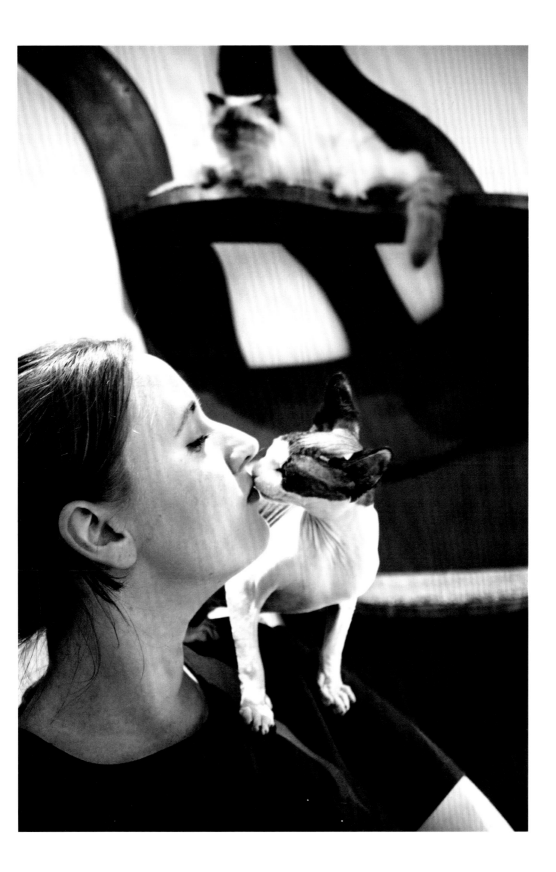

IRENE MOLINA
DENTIST AT BRITENDENT CLINIC

The satisfaction of my profession is to create a smile for every single person I treat. The more people dare to smile, the happier the world will be.

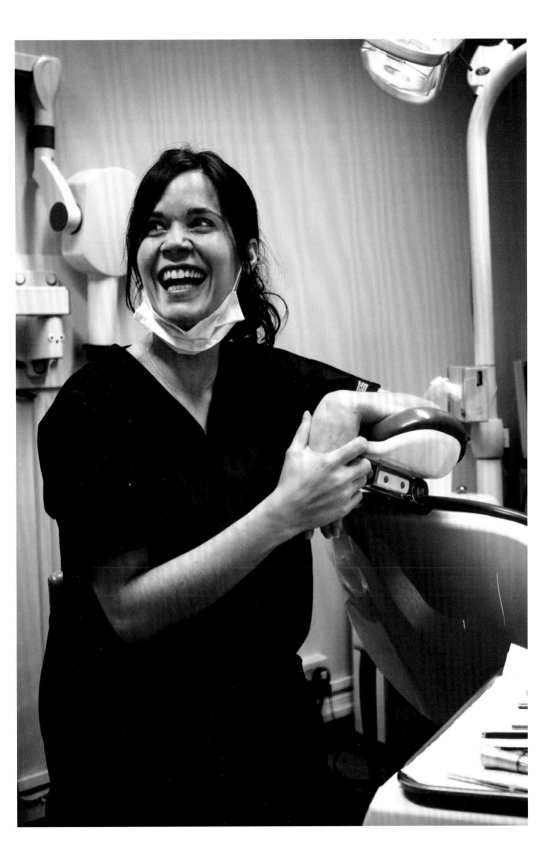

ALWYNE SIENKIEWICZ
OWNER OF ENCHANTMENT

I went to my first spiritualist church when I was four and a half years old, so I have understood many things throughout my lifetime. After all, our body is just a shell. It is just a house for our soul, a house that will become ashes. That's all it is. Humanity is not ready to understand all of this. Everything is about greed and power. That's what makes me sad, not for myself but for the youth of today.

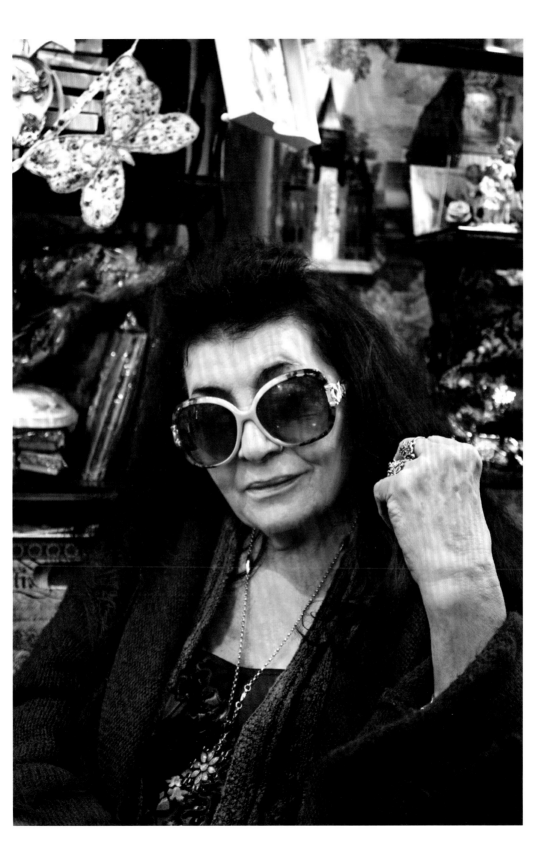

MORVERN CUNNINGHAM
FREELANCER PRODUCER

I feel privileged to be able to affect my local visual environment through the commissioning of public art around the Leith area. It's an aspect of LeithLate that I never anticipated at the beginning of the project, but has evolved to become a facet of the festival's identity. Our intention with these street artworks is to briefly take people out of the everyday when they pass by, making the routine negotiation of their surroundings a little more magical.

DANUAL DIOR
PIRATE

I am the captain of a ship called The Wytches Revenge, *that I take from here to the Mediterranean Islands and I trade scarfs and jewellery from my ships in different little harbours. As I go along, sometimes people come and want to be crew for me. My sailor friend and I were the first Scottish captains to take a Scottish boat to Sarandes in Albania. I'll chase anything from my boat, so I am the magic, but I am a captain.*

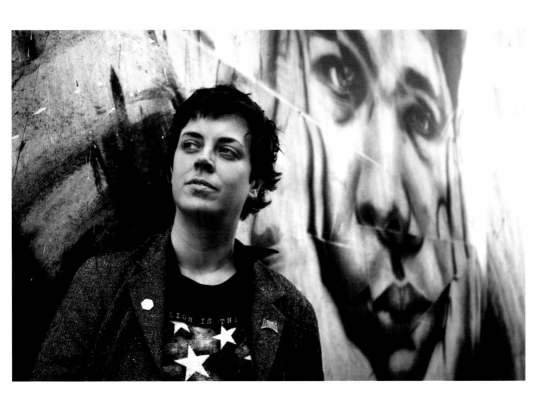

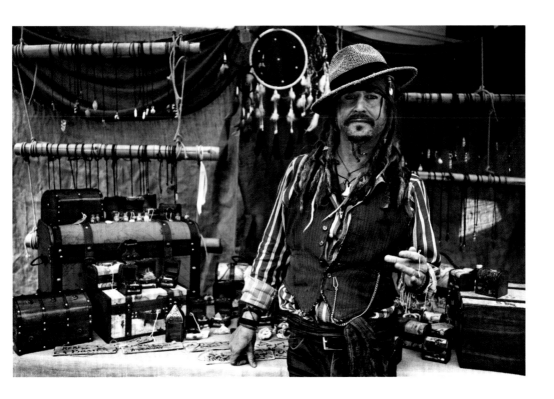

STUART HEPBURN
OWNER OF VARSITY MUSIC

I have been in Edinburgh for the past forty-five years, and I have had this shop for the last thirty years. We have sixty-five different instruments, and I play lots of them. Music is my life. I have been living for music my entire life.

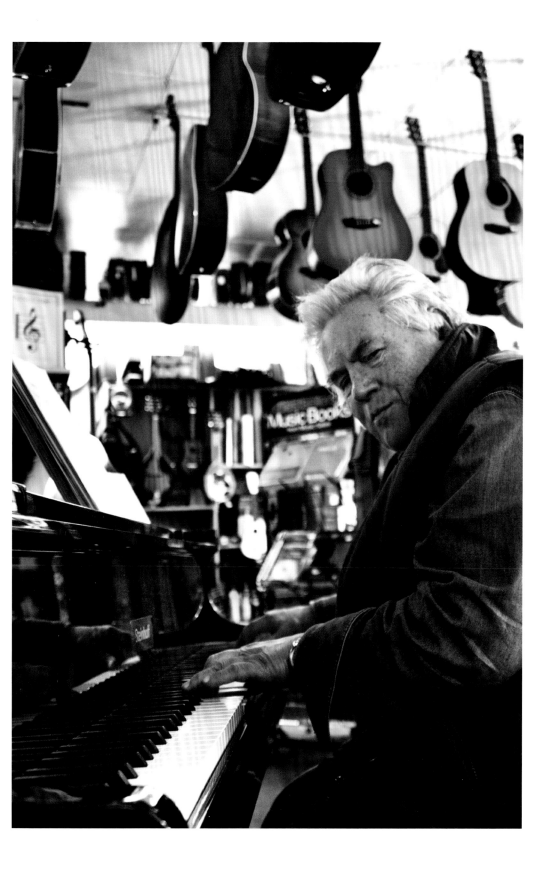

CHRISTOPHER RUTTERFORD
MURALIST

I am an enthusiastically bearded Scottish artist. For the last few years I have been specialising in epic public artwork. I always time-lapse the creation of these works and I have recently taken my making murals live project to public spaces, forging new and exciting ground in public engagement in the creative process.

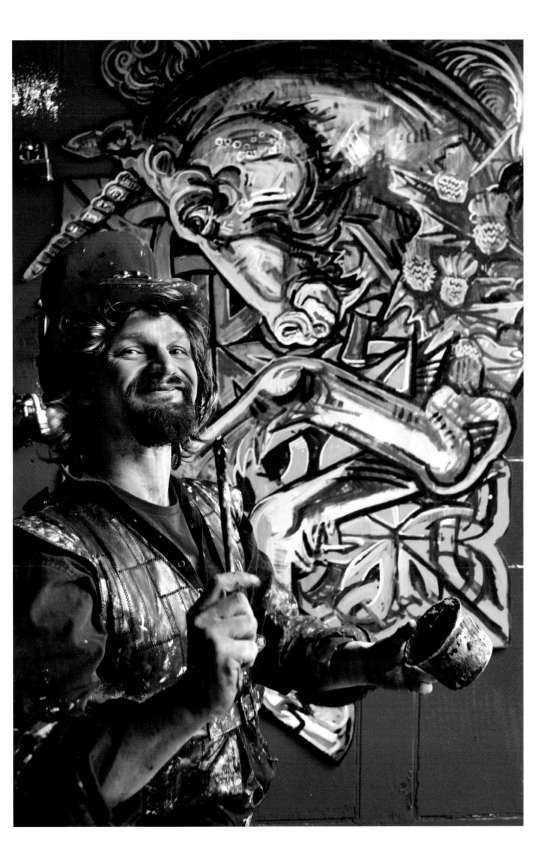

KEVIN BAINES
BAGPIPE MAKER

I have been making bagpipes since July 2015. Everyone at Kilberry Bagpipes has played pipes at the very top competition level and we all understand every aspect of learning and playing bagpipes. We are more than happy to pass this experience and knowledge to people.

NICOLE ROBERTSON
BACKPACKER

Ten years ago I was told that I would not be able to do the things I dreamed of, like backpack the world, immerse myself in different countries and cultures, and see how the other half live, because I have an immune disease. No one should ever be told to give up on their dreams, at any point in their life. So I travel. I backpack the world. I immerse myself in different countries and cultures, because I believe that I can and because I was told that I could not.

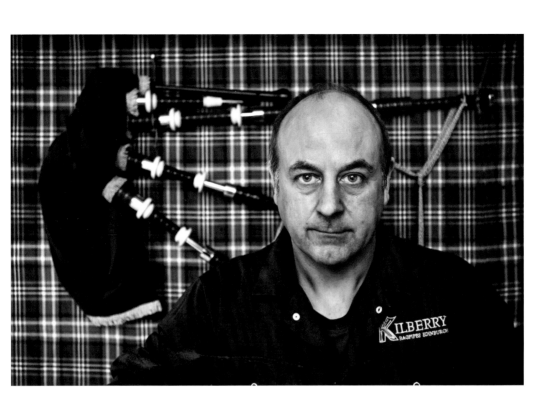

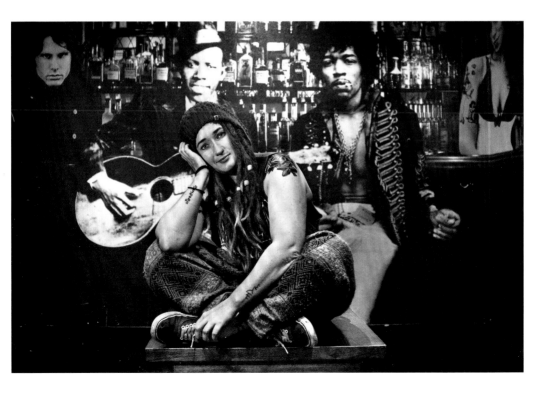

MARC DIAMOND
TATTOO ARTIST

I have my story written in ink under my skin and over most of my body. It's the tale of my personal adventures, marking memories in my life, reminders of moments in time, like snapshot photos in an album. I remember where I got each one, who did it, and the tattoos themselves speak volumes to me.

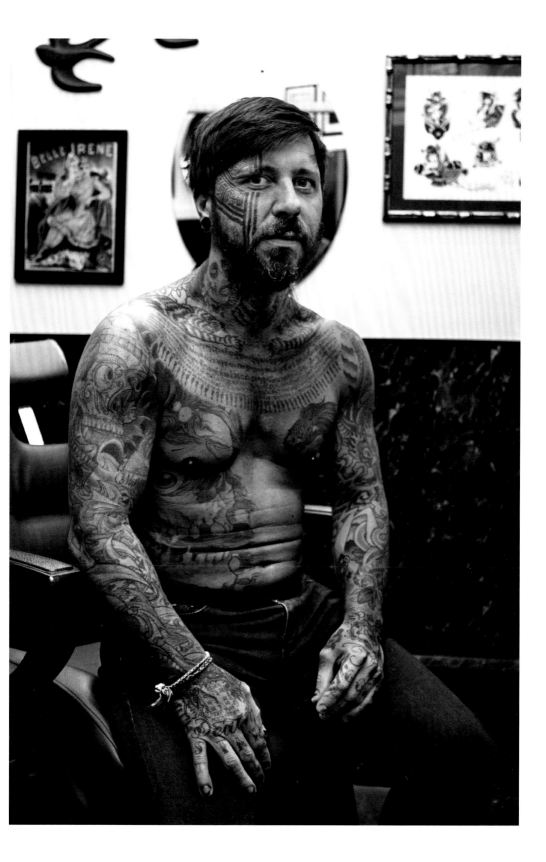

JOEL PEREZ-NEGRIN
THE LITTLE MERMAN

When you live in a small village, imagination can help you to overcome difficulties. Bullying in school, being different and things like that. That's why I always loved The Little Mermaid, *a fairy tale about someone who wants to be different, who wants to be somewhere else. I knew I would leave someday and no one would ever tell me 'you can't do that' or 'you can't wear that'. Love yourself for who you are and be yourself. It takes too much energy trying to be somebody else.*

FACES OF EDINBURGH

GEORGIOS NTAVELAS
DEMONIC OBEDIENCE FOUNDER

Metal music is a way to express your deepest feelings in order to protest against any kind of daily oppression. This is what I love, and this is what I am trying to achieve with my music.

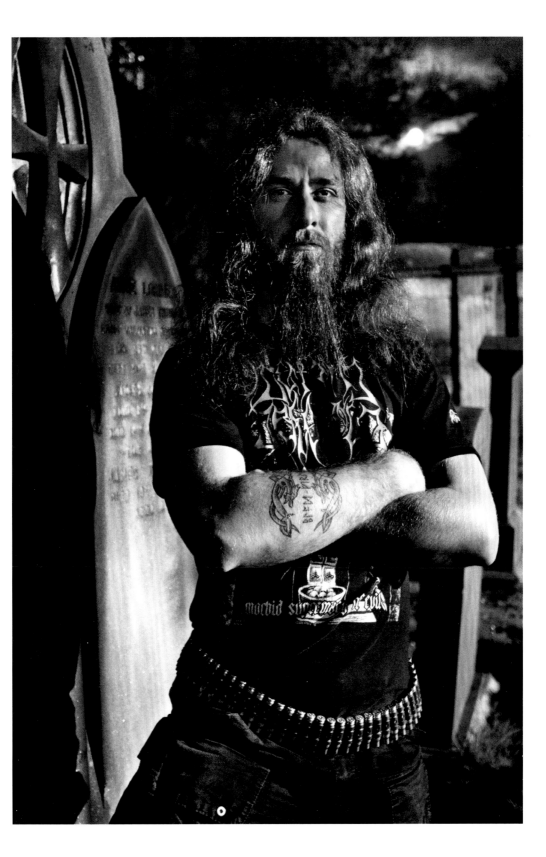

AUNG ZIN TUN
KITCHEN MANAGER, SCOTTISH NATIONAL GALLERY OF MODERN ART

The beauty of my profession is the creativity and the different challenges faced every day. I believe that cooking is an art. It requires instinct and imagination. I express myself through food. The best part of being a chef is using living products and seasonal ingredients to create something beautiful.

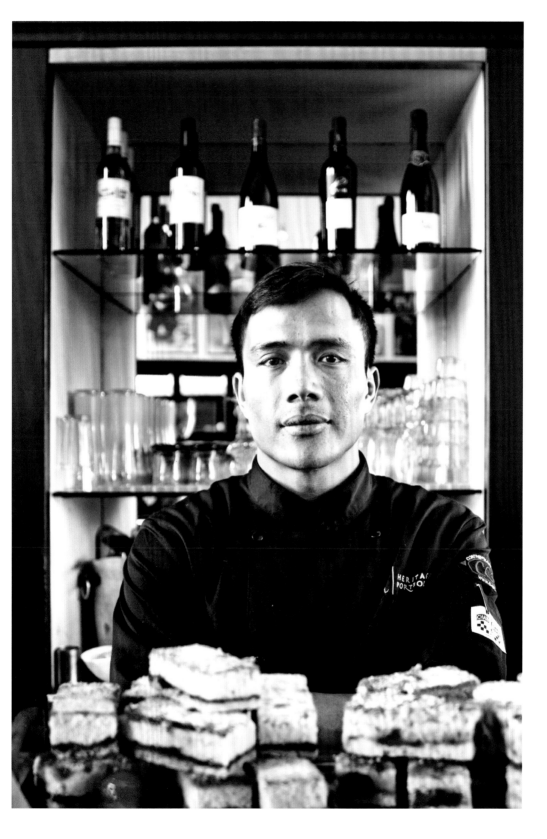

JAMES CROMBIE
HELICOPTER ENGINEER

I am a tattooed and bearded Scottish man who is known as 'Tatt Santa'. Edinburgh born and bred, and still enjoying the friendly, eclectic mix of cultures and community that is Edinburgh. Being a part of the team that keeps helicopters flying straight and safe is what has given me job satisfaction for the last thirty-five years.

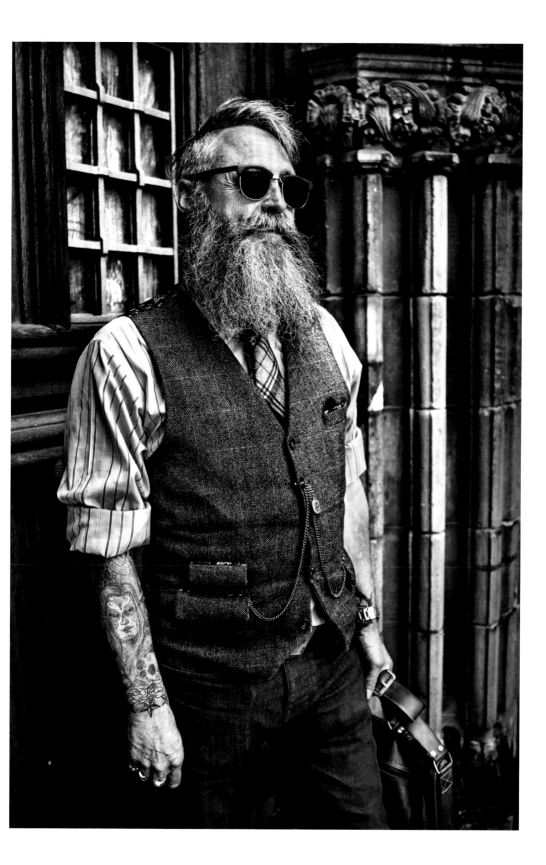

ELYSE BLACK
HEALER

I first discovered alternative healing when I was younger. Driven to discover an alternative way, I found myself studying the human body as well as reflexology. My aim is to help people in such a way that they can see and feel for themselves what I can see within them, to empower, connect and guide each other. I feel this is the most valuable gift we can offer to each other.

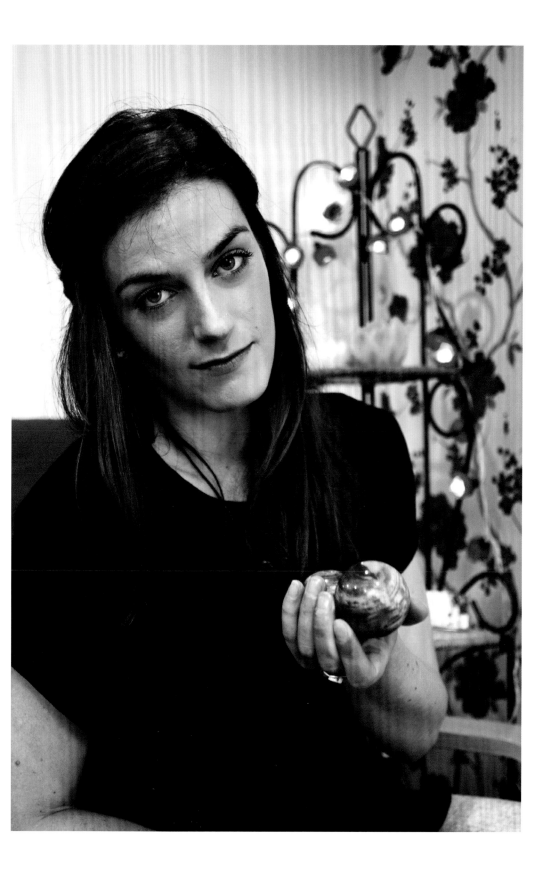

EDGAR GUERREIRO
THE SAW GUY

A few years back, I taught myself how to play the saw as a violin, and it became such a big part of my life that people usually refers to me as 'The Saw Guy'. The ability to play such an unusual instrument has taken me to several places across the globe, including Edinburgh – the city I fell in love with and the city I chose to be my home.

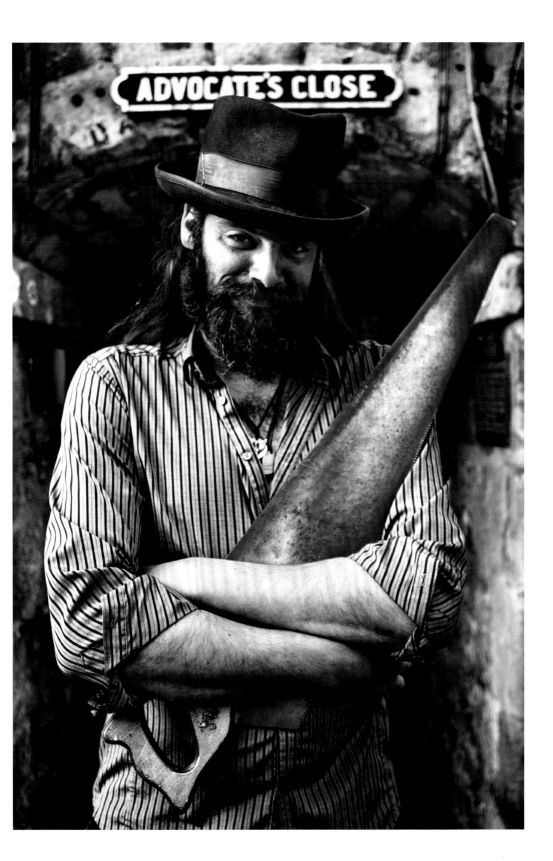

MOLNÁR MÁRTON
PUPPETEER

Puppetry is more complex than most of you would think. I guess that is why there is a cathartic moment, where you and the audience form another word, where your body becomes irrelevant and you live through manmade joints, paper, wood, clay or plastic. You are not a mimic. You create something new. That is why we do it.

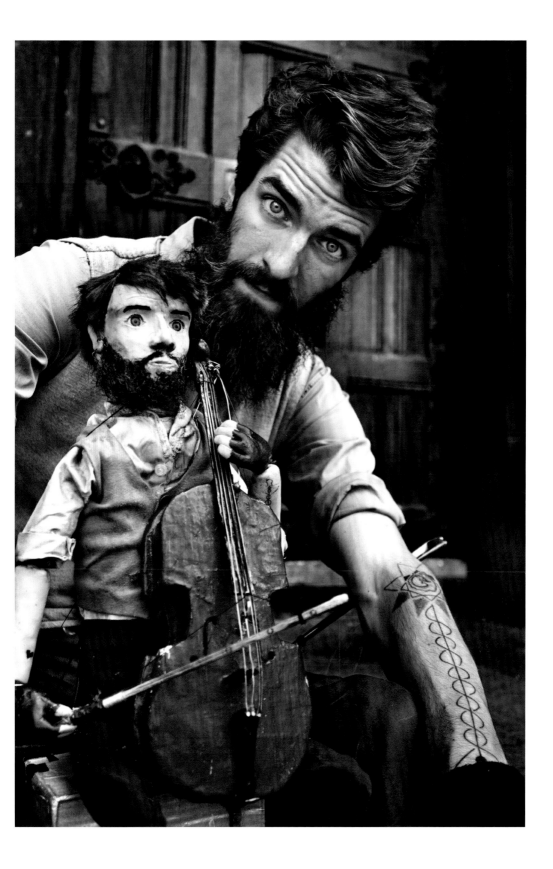

PETER MILLER
SITE MANAGER

I have been working as a builder for thirty years. My job takes me all over the east coast, also doing a lot of work for Edinburgh Council. We built the Great Britain headquarters for Mr Arnold Clark and we have also been working on the Edinburgh trams since the beginning. For us, the public is really important – it doesn't matter where we are.

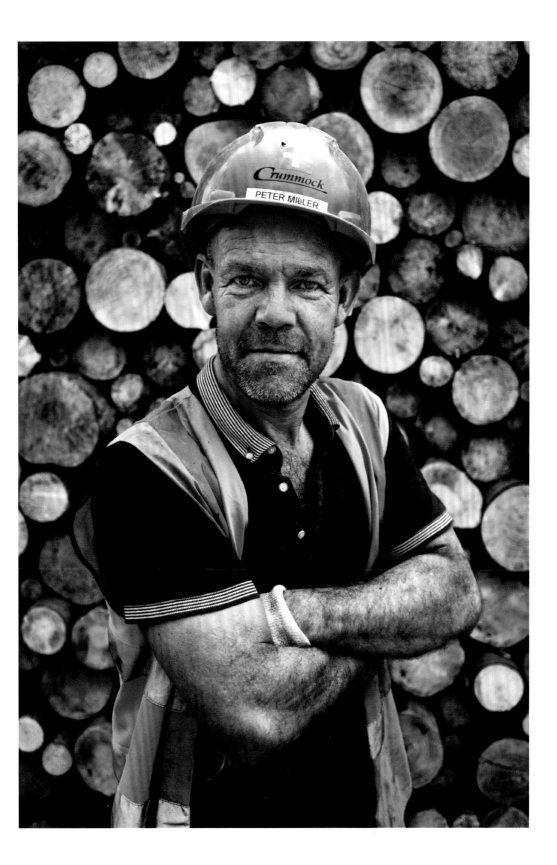

JONATHAN RUMFORD
TRAVELLER

The knowledge that I only have one life to lead is what keeps the travel bug itching; it drives me on to the next group of friendly faces with whom I will embrace the next amazing experience. There is a sense of freedom in having a backpack across my shoulders and my worldly possessions condensed to 15 kg.

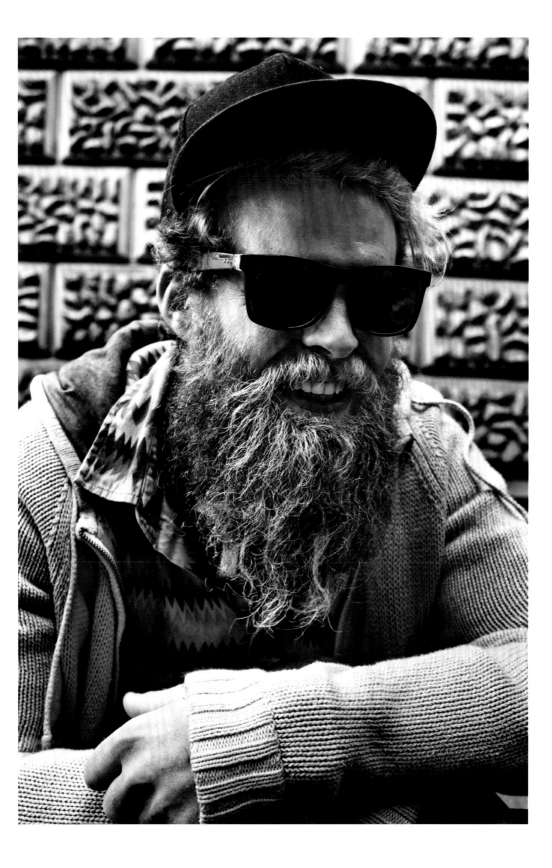

DAIVA MALINA
ACTRESS

To share a move, sound or gesture with the audience could be magical. If there is a touch of magic in anything I have done in connection with other people; if someone has smiled due to me; or if I made someone laugh, cry, or just have a thought, then I think I had a good day.

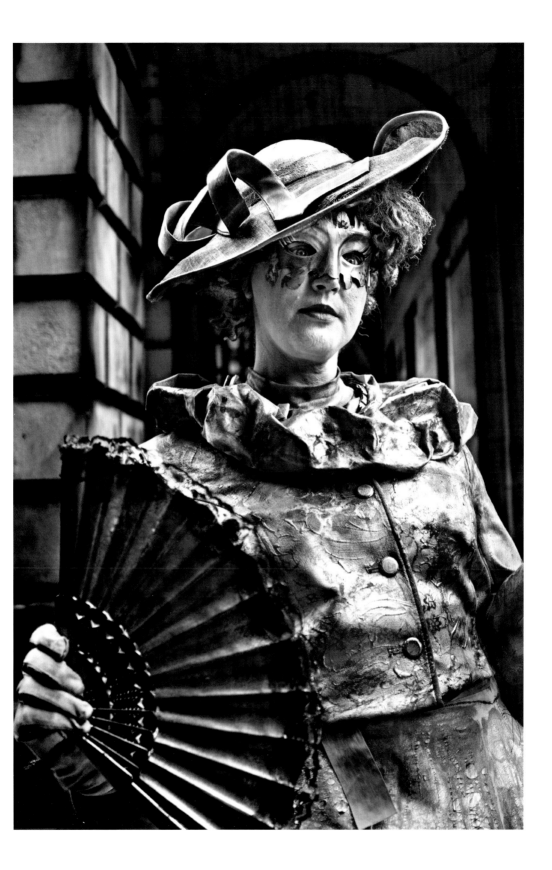

KATIE ROUGVIE
HUMANITARIAN AID WORKER AND WOMEN'S RIGHTS ACTIVIST

Working on gender-based violence and women's rights in humanitarian emergencies has taken me to numerous different conflict zones. I've seen the best and the worst in the world. I'm continually inspired by the resilience and strength of the women and girls surviving war around the world. Each time I come home to Edinburgh, the beauty of the city takes my breath away. It is my comfort and my sanctuary.

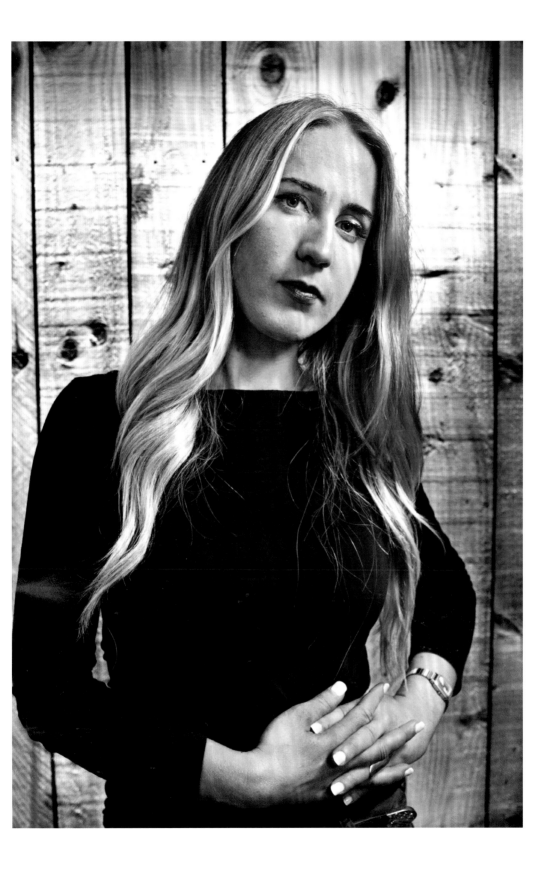

FACES OF EDINBURGH

MUZZY HAMILTON
MAGICIAN

Like most kids, I was given a magic set for my eighth birthday. But unlike other kids, I never grew out of it. Magic is a lot of fun and I do tend to be the guy at parties entertaining everyone. Edinburgh is a great city for the arts because every type of arts festival comes through here.

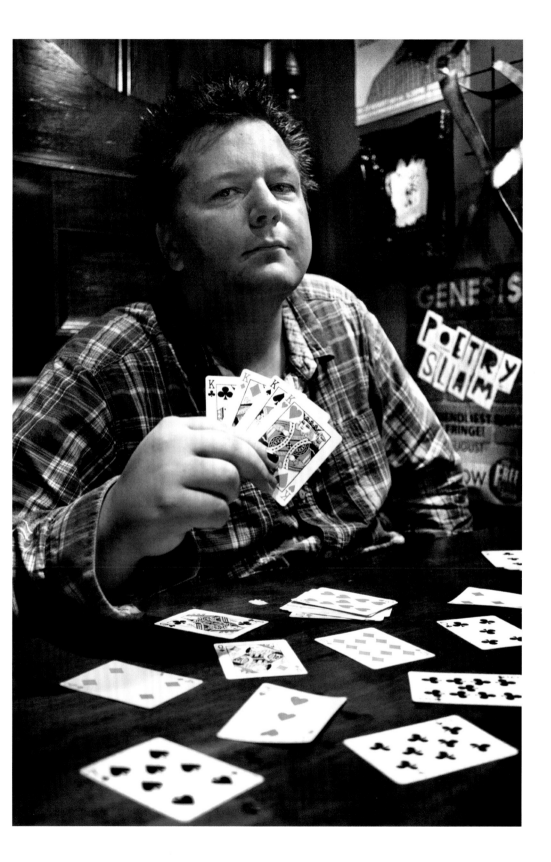

GRAHAM FENNELL
SOUND DESIGNER

I dropped out of school when I was fourteen. I wasted the next six years playing video games until I decided to make a life out of it. I began writing music on the Nintendo GameBoy in 2006 and I became so engrossed in the world of audio that, ten years later, I graduated with a degree in smashing watermelons with sledgehammers. I went from being undereducated and unemployed to working in the games industry. I owe all my success to an outdated, grey, 8-bit machine that runs on AA batteries. Life sure is funny.

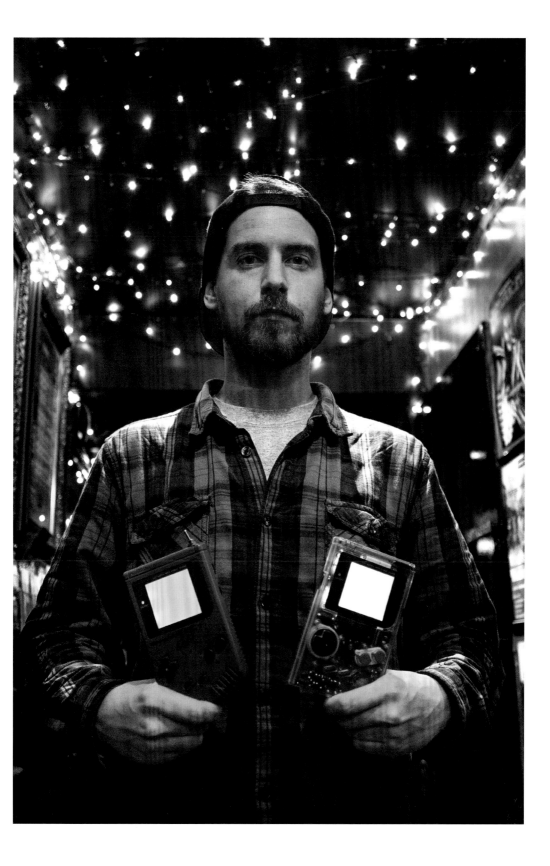

NATALIE CANDLISH
ILLUSTRATOR

I think that if you are supposed to do something then it will keep coming back to you. I think that's what happened with me and illustration. There have been times when I've wanted to give up on it but I always come back to it, like it is a part of me, so now I've decided to go for it completely.

DAVID MACHINE
MUSICIAN

My machine never stops working. I exchange experiences and knowledge with other musicians and I live life in an intense way. With my music, I fight to make everything a bit better, trying to build a world where there is room for everyone, like a flowing river.

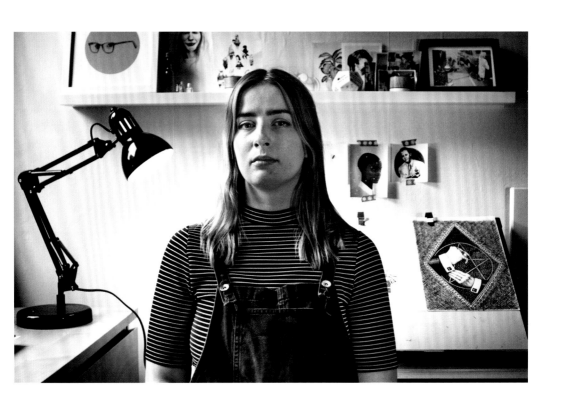

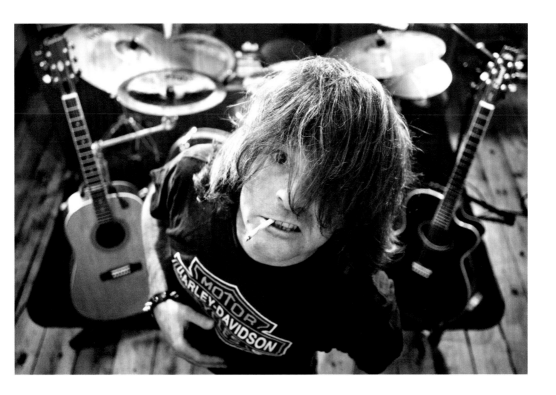

TARTAN HEATHER
SPINNER

I am originally from Ayrshire, but I have been moving back and forth between Glasgow and Edinburgh for many years. What I do is a very important part of Scottish history. I take wool, spin it, die it and create unique pieces of cloth such as hats, scarfs, or traditional Gaelic Scottish dresses.

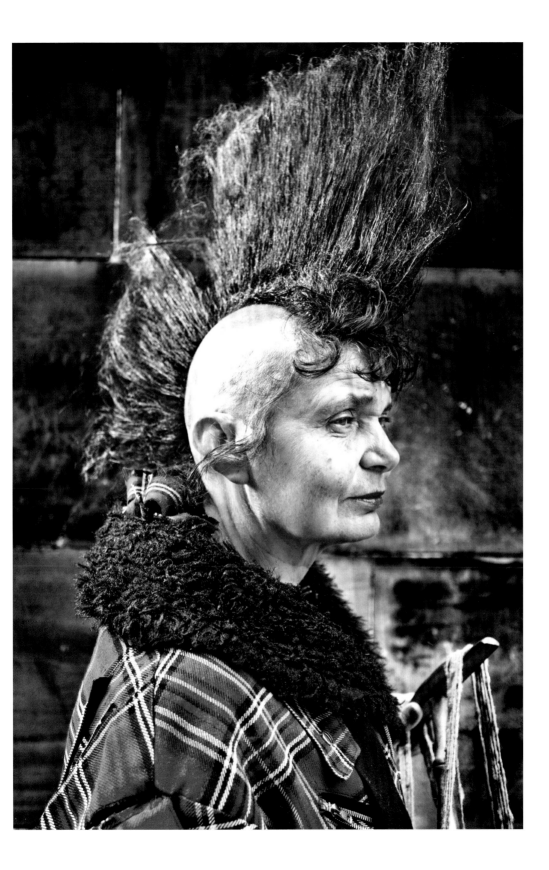

ZEENA MINDIKOWSKI
THE TALE OF THE UNICORN

I am Zeena the Psychedelic Unicorn. Ever since I was a young unicorn I knew that I did not belong to this destructive place called Planet Earth, a world full of followers. I knew I was different. Not following any path, I have lived in my own strange, surreal, magical and psychedelic little universe of weirdness. A place where I do not allow people to tell me who I am and who I should be. A world where I do not allow my third eye to be brainwashed by television, media and other false ideas put upon us by the system. Follow your own path. Be yourself.

SHANNON FERRY
MIXOLOGIST

From the first time I stepped behind a bar, I knew I always wanted to be a mixologist. Making drinks and creating new cocktails, whether good or bad, is so much fun. Feeling like a mad scientist throwing lots of different ingredients together and seeing people enjoying your creations is extremely satisfying.

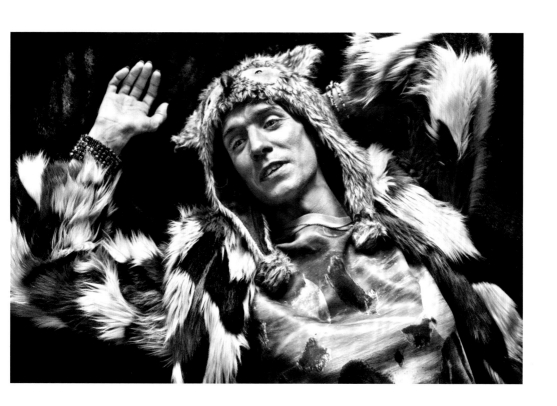

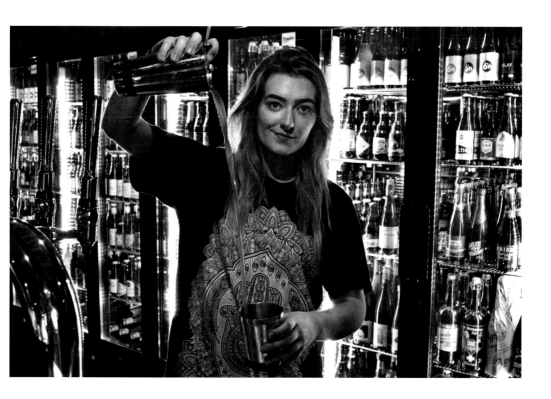

VICTORIA SANCHEZ
LOVER OF NIGHTTIME CREATURE'S BEAUTY

I am passionate about history, nature and heavy metal music. I simply love to walk through the streets of Edinburgh's old town when the night falls, letting their walls of stone tell me old stories.

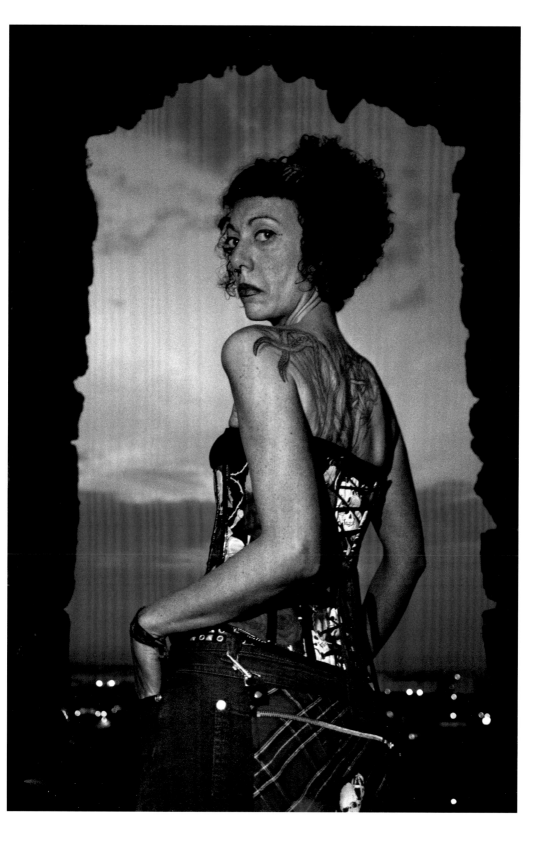

ALEXANDER SLATER
CYCLIST

Bikes are my life. They always have been and they always will be. The freedom you get from riding cannot be explained. There is a certain high you get that draws you in again and again. When I ride my bike, no matter how long or short a distance, I get a feeling of peace. Whatever is going on in my life at that moment does not matter, all I focus on is the two wheels on the ground and the ache in my legs.

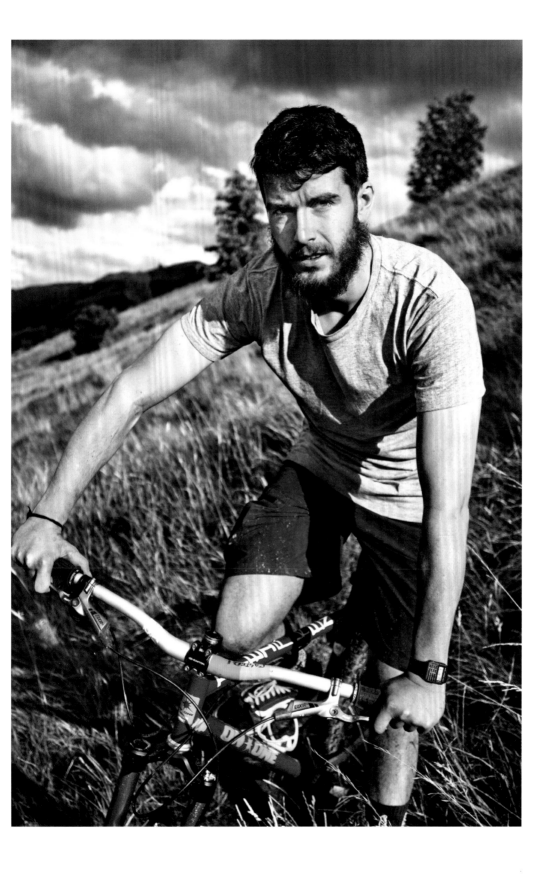

BENJAMIN FRANCIS
LONGBOARDER

Longboarding is not just a board that you jump on and it carries you to places. If you take the time out of your day to go boarding and put on a good song, it's the feeling of being free and clears your mind of everything – hitting a hill at the speed of cars but right in the wind and elements. I cannot think of anything better in life than this.

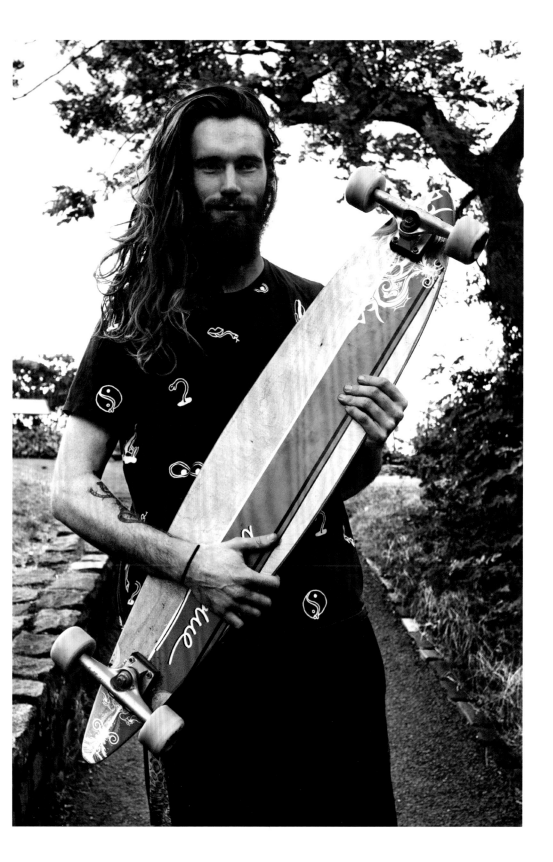

ROSS HEPBURN
COMEDIAN

When I was seven years old I was diagnosed with Asperger's syndrome. One day my parents decided to show me the film Beetlejuice, and it completely changed my life. I struggled a lot growing up, but these people were strange and no one ever questioned them, and it showed me that there is nothing wrong with being different. Now I am a standup comedian and get to become Beetlejuice when I perform.

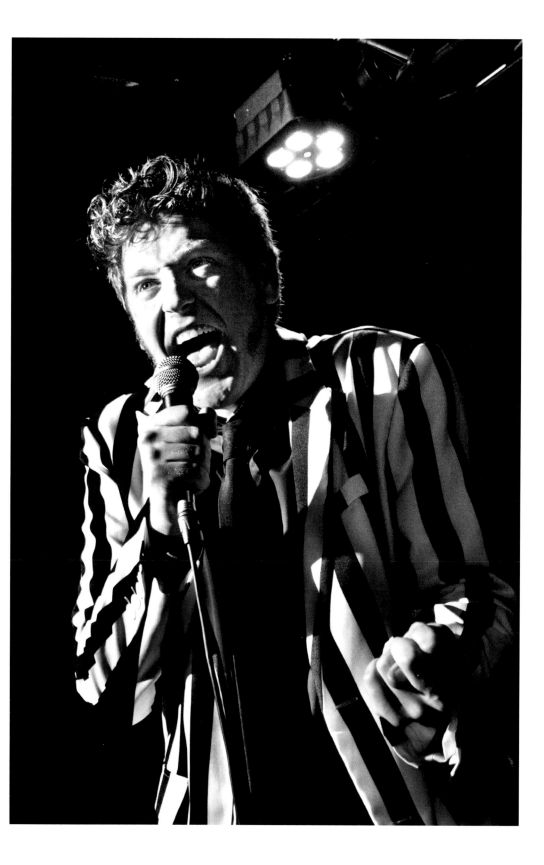

DAVID JIMENEZ
STREET ARTIST

I do a little show on the streets of Edinburgh, painting landscapes in front of small crowds. Edinburgh is a soulful city and the summers are vibrant with life, music and arts. I enjoy meeting and working with the people that year after year come to make the city a more colourful place. And I love being part of it.

LOUIS THOMAS
CO-OWNER OF THE STREET BAR

My first shift in a pub was covering for a friend's staff night out. She told her boss I had lots of experience: I had none. Twenty years later I'm still going and cannot see myself ever not wanting to do this. Been here for twelve years now, it is my second home and I have gained a second family. I consider myself extremely blessed to be getting up in the morning (or afternoon) to do something I love.

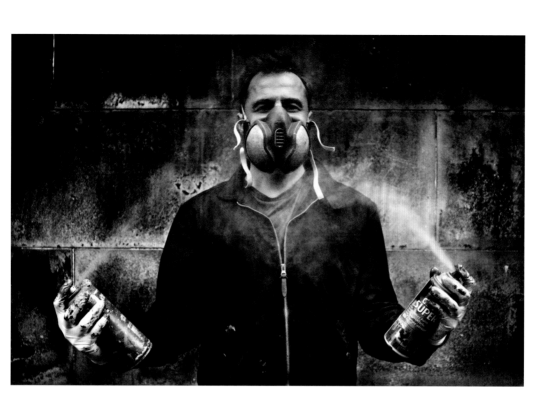

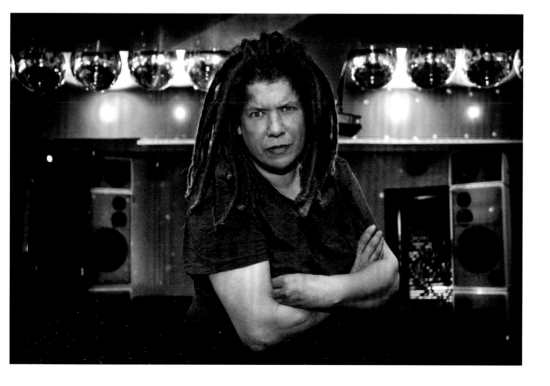

MICHAEL WDOWIAK
FILM DIRECTOR

'You have the right to remain silent because anything you say may be used as a story.' This is the only rule I follow in my work as a filmmaker. I don't feel comfortable in front of the lens, and feel like I am only truly myself behind the camera, recording people and their stories. My passion for film became apparent after I completed my Writing and Direction course at Edinburgh's College, where I directed my first short 'Yogi' which was awarded two BAFTA Scotland new talent awards for Best Writer and Best Editor. This inspired me even further to pursue my dream and never give up.

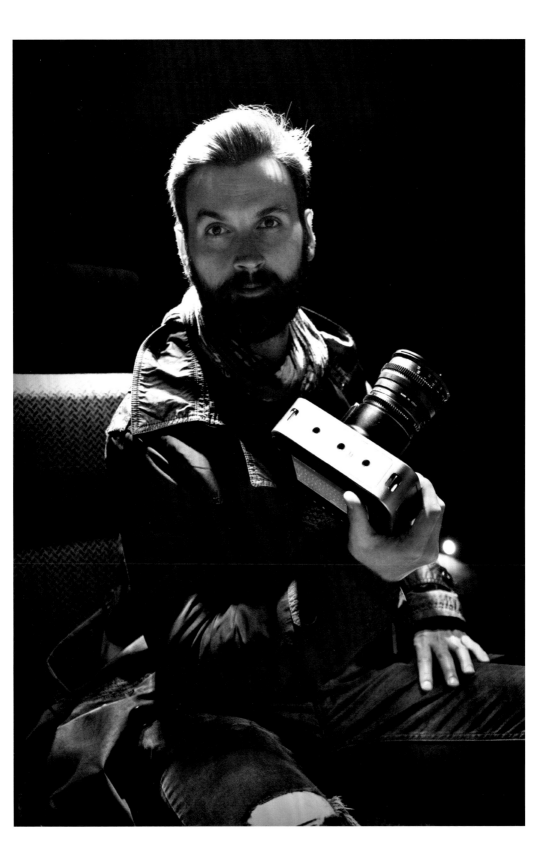

REYES MAYOLIN
SENSUAL BACHATA DANCER

Music helps me express myself with absolute freedom. It helps me escape the routine and monotony of everyday life and the problems we sometimes are forced to face. One of the best places to learn Sensual Bachata is in Cadiz, Spain, where I was born. I, however, did not learn to dance Bachata until I arrived in Edinburgh. It goes to show that no matter where you are in the world, or in life, if there is a will, there is a way.

KADDEER ASLAM
MAMA SAID OWNER

I have lived in Edinburgh my entire life, and I love the Old Town, were I work. I have two Mama Said shops in the Royal Mile, and they have given me the opportunity to meet wonderful people from all over the world. I love to meet people — the foundation on which human societies are based is socialising; it decides your happiness, your existence, and the knowledge you earn from every single person you interact with. You learn from people. Family and socialising make the difference in my life between mere existence and actually living.

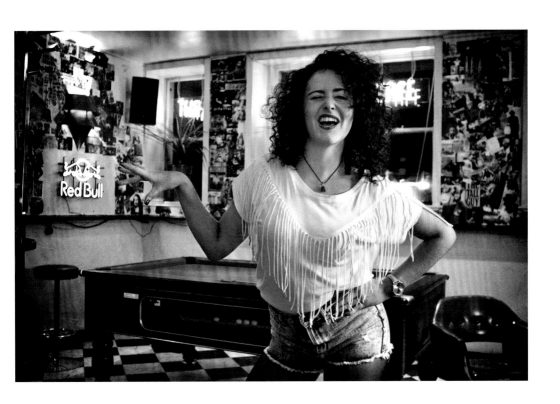

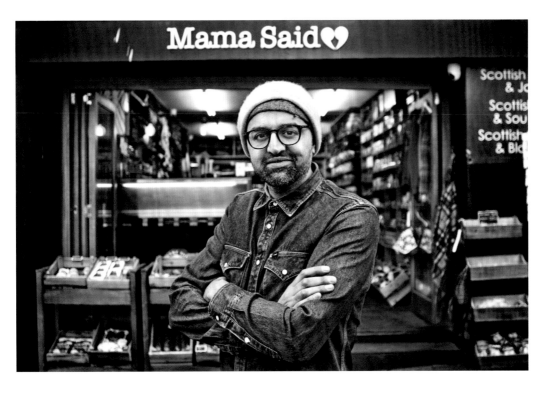

MELISSA KNOX
VIDEO GAMES PRODUCER

I am the producer at a video game studio in Edinburgh. The games industry in Scotland is growing steadily and there is a wealth of talented developers here in the capital, and all across the country. I have loved Scotland since I came to Stirling for my masters degree in 2010, but I am particularly enamoured with Edinburgh. The city's thriving culture means that there is always somewhere new to be discovered, and a variety of events to explore with an eclectic mix of people – it is impossible to be bored!

MICHAEL CLARKE
FORMER DIRECTOR OF THE SCOTTISH NATIONAL GALLERY

I have lived half my life in this beautiful city. I am frequently away on art quests, but I always look forward to my 'homecomings' and never cease to be amazed by the magnificence of the architecture and the rich cultural offering that Edinburgh provides. If the winter nights could be shorter it would be perfection!

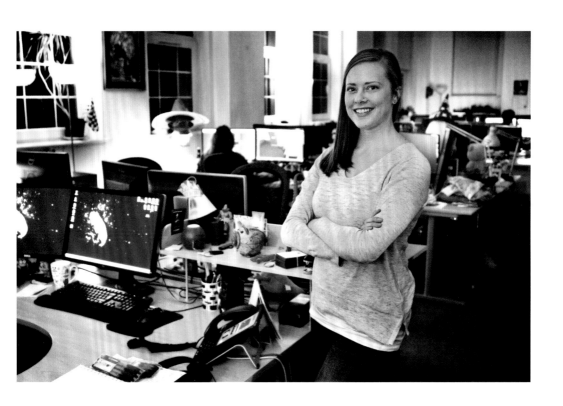

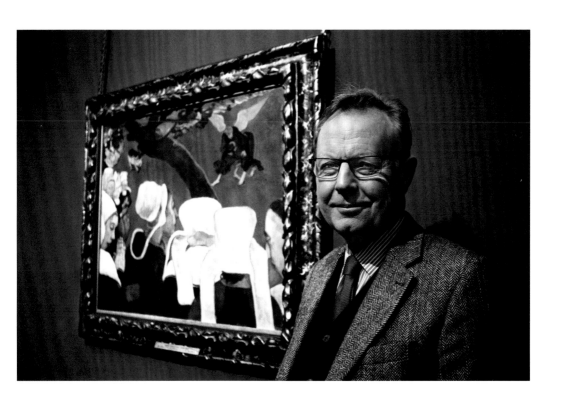

LAURA NAGELSCHMIDT
HUMAN RESOURCES MANAGEMENT

My job mixes business with culture, language, locations, travel, talent management, and employee development. I have lived in different countries myself and I have now fallen in love with Scotland, where I came to do my masters. I want to give something back and as a human resources professional I can have a profoundly positive impact on people in their workplace.

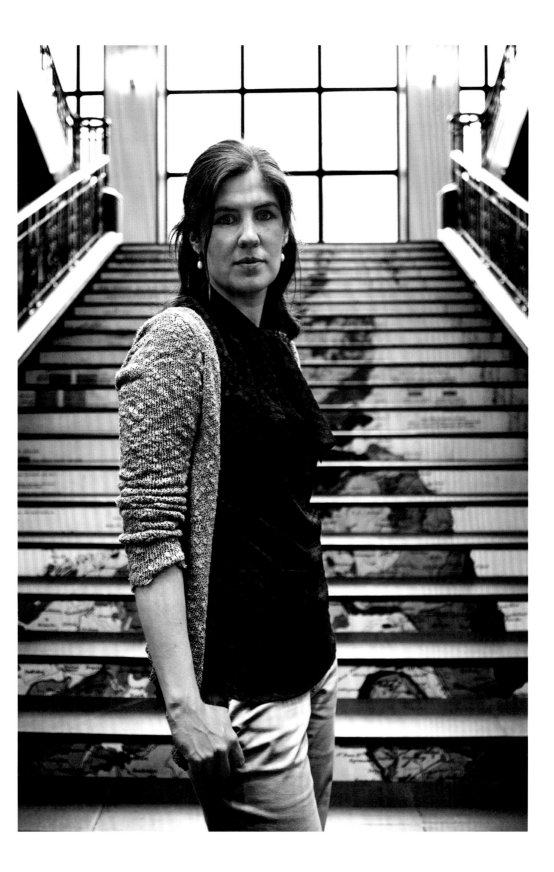

ALISTAIR STEWART COOK
THE MAD EARL OF DRUMLANRIG

The dark and damp closes and wynds of the Edinburgh Royal Mile are the perfect place to horrify tourists with Scotland's violent history. For the past 300 years I have been haunting these places as the Mad Earl of Drumlanrig, Edinburgh's most dignified cannibal.

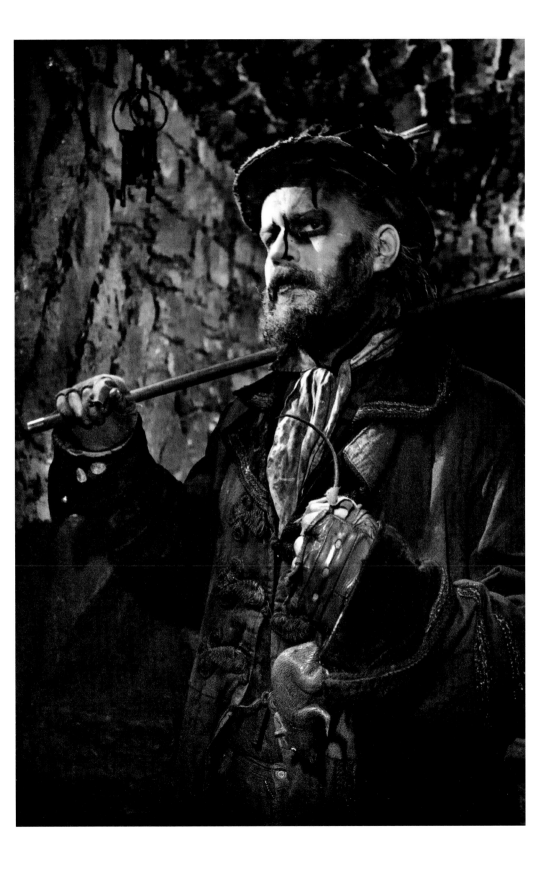

BIFF PARIS
HARDCORE VOCALIST

I have been playing in punk and hardcore bands since I was thirteen and it has been a constant positive force in my life. It has allowed me to travel and the majority of my friends I have met through playing music and touring. I think it is important for people to create some form of art, whether it is music, painting or whatever, even if it is not a masterpiece. It is a good thing to be able to express yourself in some way. Even if it is just making a lot of noise in a hardcore band.

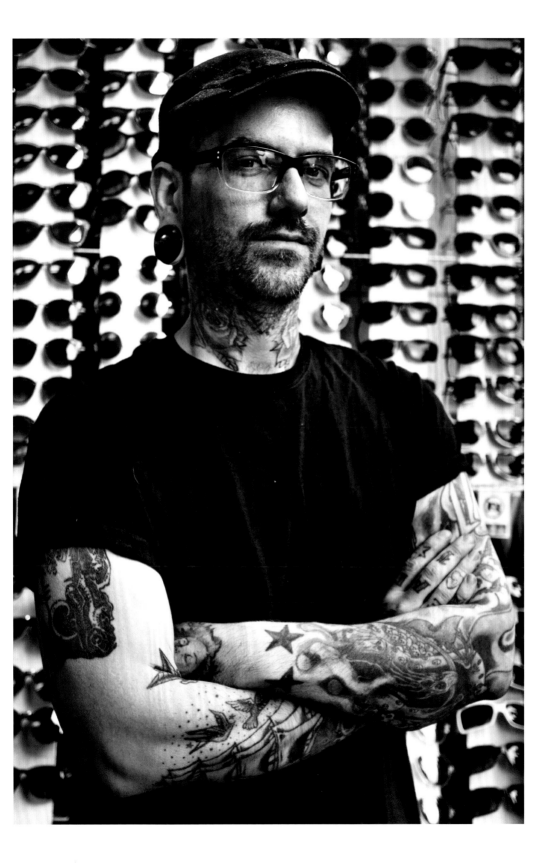

FRANCES FOWLE
ART HISTORIAN

Looking at paintings has helped me to see the world afresh. As writer, teacher and exhibition curator, I wish to share the joy and insights that works of art can inspire.

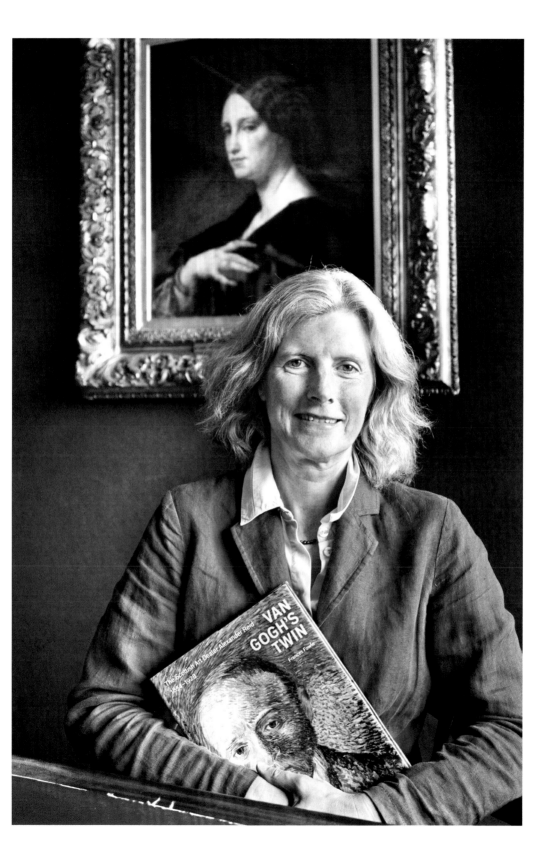

DAVID GORDON
SENIOR ELECTRICAL SERVICES ENGINEER

To be part of the design team of the new St James Center is both a privilege and an honour. A building that will change the landscape of Edinburgh for many years to come. Designing lighting and power installations for buildings is what I do and without this they would not function.

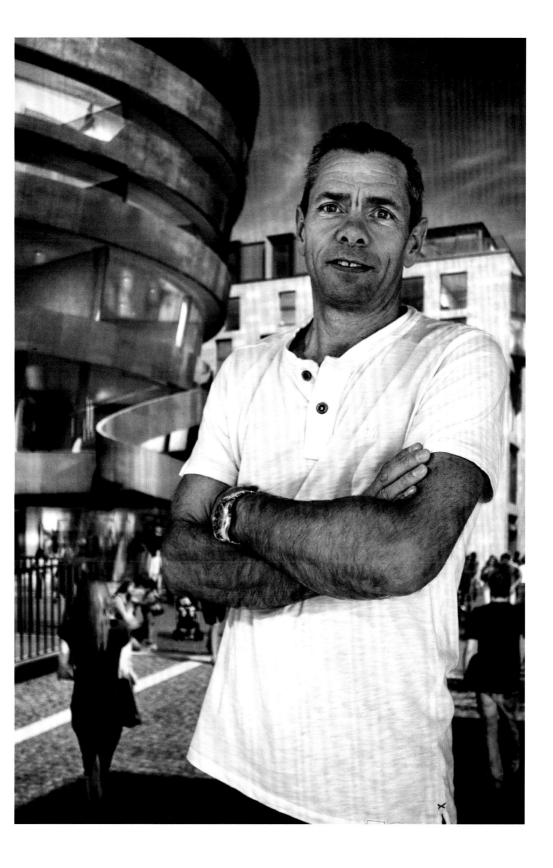

LARISSA SUSIN
HERBALIST STUDENT

A while back, I fell sick and had to go to the hospital several times. Yet no matter how many times I went and how many different medications I tried, I did not get any better. It was then that I turned to herbal medicine and I soon experienced a great relief through plants and herbs that had gone unnoticed my whole life. What I love the most about natural medicine is the limitless source of knowledge and that there is always something new to discover.

FERNANDO DIAZ
BENICÀSSIM ELECTRÒNIC FESTIVAL CO-FOUNDER

Music has always been a big part of my life ever since I can remember, starting from a young age growing up with parents who had a great interest in music. I started to drift more and more into electronic music and after years of partying in the best clubs to the best DJs, some friends and I wanted to create a similar environment, but with more people and greater atmospheres, and so we created what is now Benicàssim Electrònic Festival.

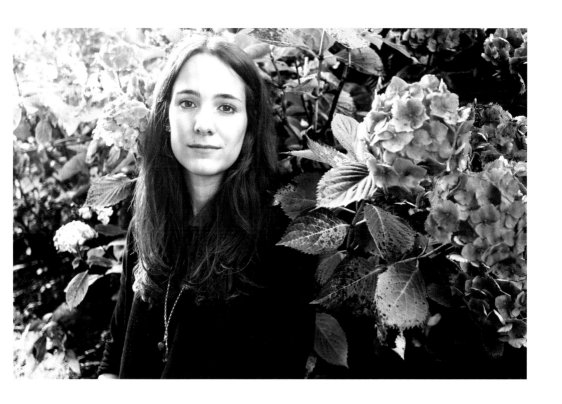

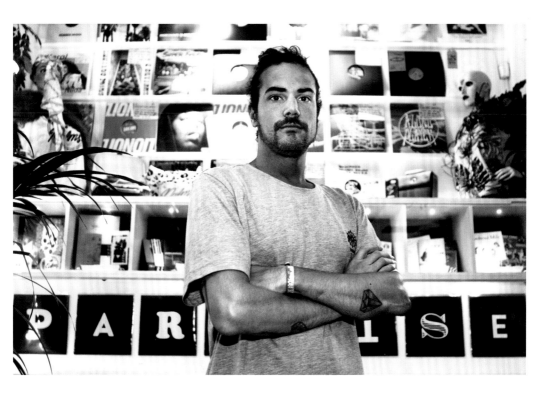

ELÉA KARLSSON
VETERINARY NURSING STUDENT

There was no alternative for me other than to work with animals, and to help them when they can't help themselves. To nurse an animal back to health is a truly wonderful thing. It is a very challenging and difficult degree but I am so happy that I chose to study and live in Edinburgh as this city never fails to inspire me.

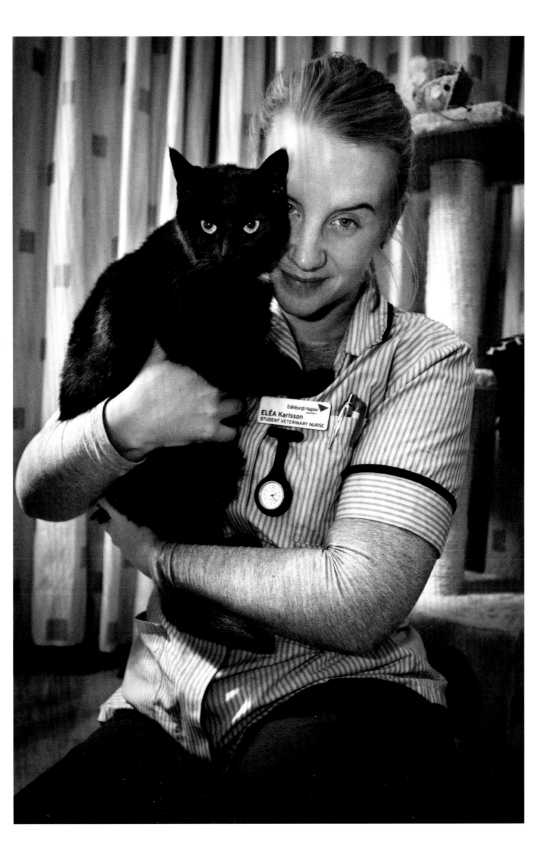

BENJAMIN SUAREZ
TOUR GUIDE IN ESCOCIA TURISMO

I believe that working as a tour guide in Edinburgh is not a job, it is a privilege. I love telling everyone that visits Edinburgh about the history, legends and secrets of this city and country and to share their amazement and fascination. It is an indescribable sensation to observe how people discover the country through your knowledge, eyes and feelings.

SUSANE MEANEY
BOOKKEEPER

I enjoy the practical side of numbers and the variety of the job from sales, purchases, VAT, bank reconciliations, management figures, and the involvement I have with other staff on a day-to-day basis. I love a good puzzle, which is a good way to describe the complexities of this business – being concise and trustworthy and going beyond the numbers.

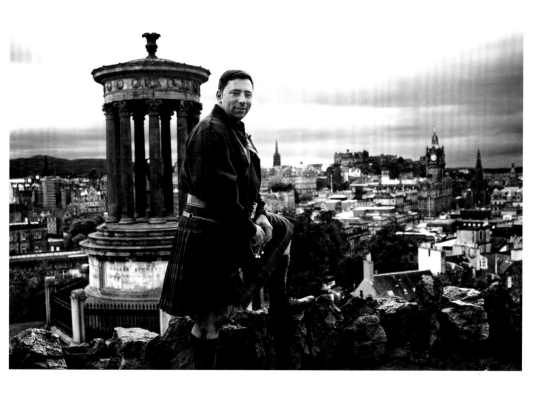

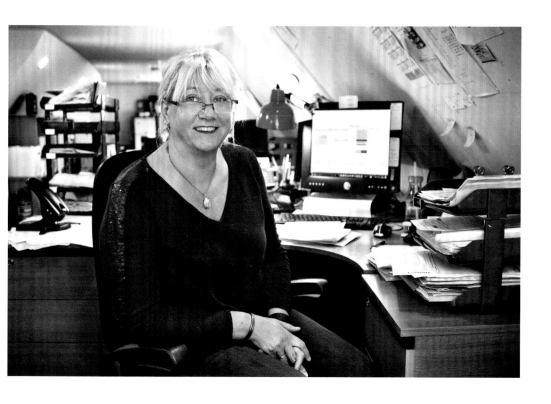

ESTEFANIA GARZON
PILOT

I am a point in the sky, an arrow, a moving beam, which touches and goes, which rises and descends, which brings and takes. I touch the screens, the levers, I turn the engine on, calculate, report, adjust and I climb; I follow directions, intercept fixed courses, glide paths, and land. The screens guide me, every sound is a warning, every light a signal, the ailerons are under my fingers, which move elevators and flaps. I move axes, change flight levels, I go in and out of invisible airspaces that guide me and receive me. I do my job as someone who is serving a mission.

ALBERTO SANZ
RUGBY PLAYER

Rugby is a lifestyle. You gain a new family with whom you learn to value things differently, not just in the field, but in everyday life. One learns to respect and appreciate not only your own colleagues, but most importantly, to respect the opponent as if they were part of your own team. I love rugby.

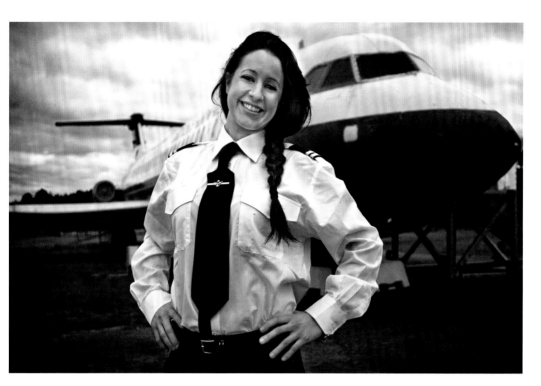

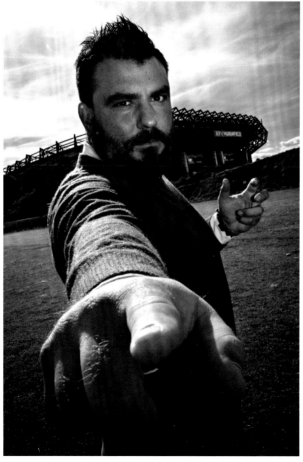

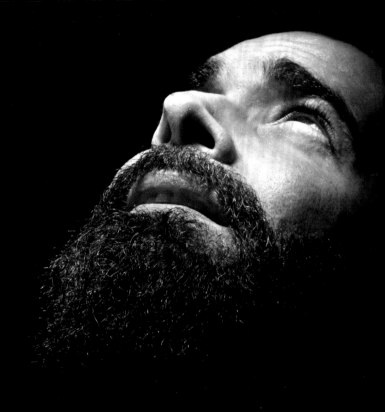

MANEL QUIROS
DOCUMENTARY PHOTOGRAPHER

As a documentary photographer, I create a link between people who need to be heard, and people that need to listen. I document social issues and marginalised communities in need, raising their voices to the world. This has proved to be a very valuable lesson, allowing me to realize that some problems in the world are more than they may first seem, and reaffirmed my belief in the importance of documenting them. My personal choice and what inspires my work is to promote a collective conscience.